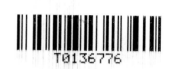

VISIONS AND REVISIONS:
Robert Cumming's Works on Paper

August 24 to November 3, 1991

Andrew Stevens, Curator

Elvehjem Museum of Art
University of Wisconsin–Madison

Foreword

Robert Cumming's acclaim as a photographer and as a painter, his sculptural commissions, his books, and his voluminous production of works on paper reflect an intellect continually and creatively interacting with the world around him. Delving into any of his works reveals meanings within meanings, rich references to the history of art and his own works. It was this intellectual approach which prompted the museum's first purchase of one of his works, the painting *Small Constellations*, and then led to the formulation of this exhibition.

It is a museum's privilege and responsibility to share with its public, as best it can, the excitement that comes with looking at and learning through the visual arts. Thus, when we first had the idea of presenting Robert Cumming's work, our discussions centered on the continual development of themes and numerous variations on the subjects of his art. So, almost from the outset, we planned to focus on this fascinating talent, to bring it to our audience in the form of an exhibition.

On behalf of the Elvehjem I wish to thank Vinalhaven Press, Castelli Graphics, Derriere L'Etoile Studios, two anonymous lenders, and the artist for helping us bring together these works of art.

The Elvehjem staff has efficiently guided this project from idea to exhibition. I especially want to acknowledge the prodigious efforts of Andrew Stevens, curator of prints and drawings, in organizing this exhibition. Other staff whose work was indispensable are editor Patricia Powell for coordinating the catalogue, registrar Lindy Waites for managing shipping and photographing of works, assistant director for administration Corinne Magnoni for coordinating essential practical matters, and Lori DeMeuse for keeping accounts in good order. We also want to express our appreciation to UW Publications, especially to Earl Madden for the design and to Linda Kietzer for coordinating production. Most of all I wish to express the museum's appreciation to the artist himself, Robert Cumming, for his cooperation in this project.

Russell Panczenko
Director

Visions and Revisions

In his essay "The Man Who Mistook His Wife for a Hat" Dr. Oliver Sacks describes the case of a musician whose medical condition prevented him from identifying things visually through gestalts. In order to identify objects and people he was forced to rely upon definitive details or to gather information from his other senses. For instance, when given a series of Platonic solids, the patient could correctly identify a dodecahedron and an icosahedron. However, given a rose, the patient described it as "About six inches in length. . . . A convoluted red form with a linear green attachment. . . . It lacks the simple symmetry of the Platonic solids, although it may have a higher symmetry of its own. . . . I think this could be an inflorescence or flower." Only when asked to smell it did he exclaim "Beautiful . . . an early rose. What a heavenly smell."

Robert Cumming's work often transports the viewer across the same chasm of perception that the musician crossed in his eventual comprehension of the rose he held in his hands, across the gap between the parts and the summation of the parts. In individual works Cumming's uninflected style combines with his skill as a draftsman to create images that seem like baffling proposals which have, perhaps, arisen from some unknown project. However, the images can suddenly effloresce into meaning when the viewer catches some hint of their inner life.

Taken together, the works reinforce one another with strands of reference and metaphor that join and part through the images. For instance, a work like *Fountain, Burning Vessel* lies at the meeting point of complex networks of imagery. This essay and the choice of works in this exhibition serve as an attempt to trace part of that network; they also serve as an invitation to the viewer to mine the other veins of imagery that come to light in the artist's works. The effort is rewarding; for, by following the development of some recurring images in Cumming's work, we are allowed a closer look at one artist's creative process, not only as it shapes and reshapes images in various media, but as it builds and rebuilds the significance of what become iconic forms.

Robert Cumming's work has often addressed the inherent dilemmas of representation. Using a broad range of media, he has consistently explored the ways in which images represent and misrepresent. Even the title of a collection of photographs from 1969–1971, *Picture Fictions*, reflects the artist's interest in the photograph as an untruth. The book includes images created in the studio to fool the eye as well as images from the urban landscapes of Wis-

consin and of California, where he moved in 1969, a period when the artist became increasingly aware of the artifice of these landscapes. The photographs range from the improbable (a home in Milwaukee in the shape of a houseboat, with its attendant birdhouse in the shape of a lighthouse) to the subtly false (a photograph of a truck with a sign taped to it reading "A truck is an object"). The picture fictions dwell on the paradoxical property of photography to affirm and deny its own reality. Consider his set-up shots of events such as a chair and bucket falling over in which the viewer can see the wires that hold the scene together; the same photograph at once conveys the scene's reality and the cues to the scene's falseness.

As in his photography, Cumming's representational drawings and prints often balance an illusion against innate qualities that undermine that deception. These hand-made media generally have less seductive precision than do photographic images. Instead, one pleasure in appreciating drawn art is in the play between our ability to perceive the drawing as marks on paper and to grasp its representational significance. Savoring subtleties of line and hue generally also distances us from the illusion of the work, just as diving into the works' illusions can make us oblivious of the system of marks that creates it. This wavering of a drawing between being mere marks on paper and resolving into a comprehensible image is the source of one enduring pleasure of the art. Cumming's drawings and prints, like his photographs, often work in this shadowy area where there is an easy vacillation between the work of art and the objects represented.

The transformation that occurs when we shift our attention from the physical drawing to the object portrayed is particularly clear in a work like *The Red Chair*. Here a simple chair drawn in rigid perspective is printed over a freely drawn skeleton. In the process of looking at the work, a viewer can pass into successive stages of understanding. The phases proposed here are perhaps applicable more broadly; we may go through these stages in looking at any work, but the structure of *The Red Chair* and other pieces by the artist makes the transformations our perception undergoes especially apparent.

In the first phase of our looking at this work we are aware of its two-dimensional design, a black field with red and white marks forming in part a kind of crosshatching. Very quickly, however, we separate the work. Now the chair and skeleton seem to disentangle themselves from each other before us. The

difference between the styles and colors of the two drawings lets us distinguish them quite easily; it is as if we can pull one or the other free of the picture plane. This separation of the images happens at an almost automatic level of our perception. However, once we have separated the images we are faced with the problem of reuniting them. We can not go back to that state of naive perception easily, where the works were devoid of the associations with chairs and skeletons, and so in trying to understand the combination of the images here we might turn to anthropomorphism (skeletons can have arms and legs as can chairs). Other sorts of links are possible too, of course, but the work forces us to consider the interesting set of mental gymnastics that may be performed simply so that we can link two images which are so intimately related in the print.

Cumming has had an abiding interest in the way we place images in these intellectual relationships. One of the tools he uses to explore it, as in *The Red Chair*, is drawing style. Particularly interesting in this regard is his use of conventions of drawing borrowed from architectural and mechanical drafting.

Like the chair in *The Red Chair*, the box in the print *Burning Box* uses many of these conventions to allow the viewer to pursue the progress of image turning into idea.

The conventions of mechanical drawing, the thin-lined outlining of objects in simplified form, are used in order to convey information efficiently. They are a form of drafting that is continually used to refer beyond itself, as a plan or a proposal for the construction of some object, be it machine part or building. Consequently, when we are presented with an elevation and perspective view, as we are in *Burning Box*, it is a great temptation to look beyond the print to the object it seems to propose. This sense that the viewer gets of the box being in some stage of production is reinforced by the pattern for the flame stencil included in the image and by the naming and renaming that seems to be occurring on the image.

However, if we do dwell upon the imaginary object, we are in danger of losing sight of the work in front of us. However much it may look like a plan, it is a work in itself. Similarly, however much it may look like a watercolor, it is actually a woodblock print. Once again, the viewer is faced with the transformation of the image by nearly automatic mental process. In grasping the object we may be diverted from the central issue. We are still faced with an enigma and have not yet quite caught the scent that will reveal the works to us.

This holds true for many of his drawings. For instance *Burning Palette* and *Burgesia Palette* have all the hardness of outline and consistency of line that an architect making a final drawing gives to a proposed building. Likewise, *Prop-up Palette* has a sense of physical possibility that makes it plausible as a free-standing object. Moreover, since the artist made three-dimensional maquettes of the palettes and may realize them as objects again, the potential for these drawings as objects is very real. This possibility of further realization of a given shape or image adds to the aura of significance that the images possess and can end up helping to lead us beyond simply grasping the object that is represented.

The appearance of a vocabulary of shapes confers upon each a significance that expands with reappearances. An example of this is the wrapped ball that appears in several forms. In this exhibition it appears first as a roughly stitched-together ball in *The First Three Minutes*, implying, perhaps, the expanding universe coming apart at its seams. Then it takes on a more coil-like shape and a dark intensity as a watercolor, and then a greater physical presence in the monotype *Black Ball*. Finally it is paired with an autumn leaf in the more lyrical *Small Chemistry*. The mere act of drawing this object imbues it with a significance, which mounts with additional renderings. The viewer is invited to search for associations, perhaps in the coils of the dynamo or the endless spirals of natural processes: from galaxies to pine cones, from tornados to subatomic decay. Further, an image of a carefully wrapped ball may also remind the viewer of Marcel Duchamp's *With Hidden Noise*, now in the collection of the Philadelphia Museum of Art. Duchamp placed an object in the center of the ball and then locked it between two metal plates, closing off its ends. What was in the ball was his secret.

Cumming himself feels that though his work may have points of similarity with Duchamp's work the two artists have very different sensibilities. Nevertheless, Duchamp's *With Hidden Noise* is a model of how an object can be endowed with significance. Whether or not Cumming had it in mind as a reference for his own works, his handling of the ball image, first putting it in the implied narrative of the *First Three Minutes*, then making it darker and larger in watercolor and monotype, and then using it to evoke the equivocal beauty of fall endows the ball of twine with an unspecified significance. The viewer finally does not know what lies within either artist's coils.

This sense of portent that is bestowed upon mundane objects runs through Cumming's work. We see many of the images that reappear in this exhibition in the suite of drypoints in *The First Three Minutes, Etc.*, produced at Vermillion Editions in 1987. *The First Three Minutes, Etc.* declares with the spiral funnels on its title print, reminiscent both of atomic decay and the continual expansion and contraction of the universe, that it is about the first three minutes of the universe. Certain elements of the other eight drypoints of the series, for example the radio telescope, may refer to physicists' pushing back our hypothetical knowledge closer and closer to the very moment of the Big Bang. However, even these elements seem caught up in much more than a simple narrative.

Part of the complexity of the series stems from its use of shapes that become almost iconic in Cumming's work. One such shape is developed from early New England tombstones (a fact mentioned in the catalogue to an exhibition of Cumming's works at the Castelli Gallery in 1988). One variety of tombstone carried a death's head which had an outline like an electric light bulb; this is the shape used in the lithograph *Apex Oculus*, where it has equivocal associations, with light as well as with death. Another variety of tombstone has an outline which Cumming describes as a guitar pick. The guitar pick and its close relative the comma, which plays a central role in its various incarnations in Cumming's book *Equilibrium and the Rotary Disc*, appear in *The First Three Minutes, Etc.*, in *Sentry Knox Norad*, and *Fright A/C Kite*. It later is transmuted into the shape for a palette and discovered and transcribed from an illustration of a prehistoric horseshoe crab in Stephen Jay Gould's chronicle of a rich fossil bed in his book *It's a Wonderful Life*. These variations are recorded in the drawings *Burning Palette*, *Burgesia Palette*, and *Prop-up Palette*. The shape brings with it the associations of the death's head and picks up an association with rebirth in a drawing which relates the palette drawings with the image of a sprouting coconut palm; *Burgesia, Palette, and Palm*. The monumental fountain structure of *Water Above/Water Below*, approaching the shape of a pushpin, is a further development of this elemental shape. Given a wriggling tail and turned head down, the shape becomes a flame in *Burning Box* and in the small monotype *One Fuel/One Flame*.

This relationship between the death's head and the flame is probably less a simple transformation of the guitar-pick shape than it is a conjunction of that shape with the theme of burning which develops independently, for example in the small drawing *City I*. This theme of burning appears in a series of monotypes preparatory for the woodcut *Odessa*, where the cloud takes on a more ominous mushroom shape, and then into a second woodcut, *Alexandria*. Consequently, by the time the guitar-pick shape appears in conjunction with the flame shape in *Fountain, Burning Vessel*, the associations with both have become as dense and many-layered as a rosebud though their continual reexamination.

Cumming's approach to his art is especially suitable to this exploration of images, for he is a continual sketcher, as an exhibition in Amherst with more than 300 of his drawings demonstrated. These were made in notebooks, on pads, or whatever paper was handy, as a sort of visual notebook, which then could be referred back to; the tack-holes in the *Four "M" Mesh* drawing hint at the way these drawings were used: attached to the wall of the studio as potential source materials. Like completed works, they experiment with motifs and images so that there is an active interplay between sketches and the finished works.

The two sketches for the print *Four "M" Mesh* in *The First Three Minutes* seem to plan out the major elements for the dry point. They are not, however, placed upon the grid which underlies many of the pieces in this exhibition. Ironically, this grid often appears in the traditional process of transferring a drawing; it is imposed upon the sketch to facilitate its reproduction, usually in a larger scale. Here, however, like the grid and rulers in his print *Odessa*, the allusions to measurement and scale serve as a rational, objective backdrop against which the fortuitous particulars of the scene are played out.

Given his remarkable facility in a wide range of media and the implications of reproduction of drawings, monotype is an appropriate medium for Cumming. The monotype affords a spontaneity in creating an image that is less easy to achieve in more physical media like woodcut, or even etching. With the traditional monotype, of course, there is little option for repeatability, because once the image has been transferred to the paper, only a small amount of ink remains on the matrix (the metal plate). However, monotype series worked on at Derriere L'Etoile studios were made on an offset press. The process of creating a monotype remains essentially the same: the artist applies color to a flat surface which is then transferred to paper. However, as the name implies, the paper is not applied directly to the

matrix. Instead, a roller passes over the matrix, then over the paper; first picking up the ink, then depositing it onto the paper. The advantages are twofold; the image is not reversed, as it is in non-offset processes, and a greater residue of ink remains on the matrix. This second factor was much to Cumming's liking and made it possible to produce editions of monotypes of several works in the exhibition. Unlike most traditional print editions the monotypes show considerable variation between pulls; even though ample ink remains for the next pull, Cumming reworks the image substantially—as we can see in the two states of *Adirondack Chair* included in the exhibition—changing colors and even orientation. Cumming calls the process "drawing with a press," because the process allows for infinitesimally small color changes from one printing of the image to the next, with traces of ink from previous impressions building up through as many as twenty runs through the press. It seems a particularly appropriate process for an artist for whom the permutation of images is such an important operation.

A second pull can be made from the non-offset monotype, but it is considerably weaker than the first, a "ghost" image, an example of which can be seen in the center section of *Elgin*. These more traditional monotype series are often looser aggregates of works done at the same time, often varying widely in image, although, as with the prints *Baltic Rule* and *Elgin*, the prints in these series may be quite close. These two monotypes are also closely related to a larger edition created at the same workshop. They were followed by the woodblock prints *Odessa* and *Alexandria*, which not only take up similar imagery, but use lines of very similar width and character to create the large clouds dominating all four works.

The notion of the multiple appears not only in Cumming's interest in the possibilities of the monotype. The *Eye/Mind Set*, published by The Print Club in Philadelphia is comprised of four dark renderings of monumental objects. Emily Dickinson wrote the four-line verse that gives the works of the set their titles and is printed, one line to an image, across the bottoms of the lithographs: "The Mind is smooth— no Motion—/ Contented as the Eye / Upon the Forehead of a Bust—/ That knows—it cannot see—." The poem has a marvelous confusion of pronouns at the end (which knows, the bust? the mind? or for that matter the eye or the forehead? Which sees?) that ensures that it will always remain enigmatic. It invites us to guess, but not know; it

holds its peace as securely as these silent monuments. In sorting out the text (which is withheld from the titles, giving the viewer more impetus to decipher it from the print) we are drawn to other details of the works. For instance the small openings, doorways or windows that seem to be let into them at the base or midway up their fronts, that hint at a monumental scale. Close inspection also gives the viewer access to the colors that suffuse what at first glance seem to be monochrome images and linear pattern within what at first seems all tone.

These monumental structures are kin to architectural images like the *Apex Oculus* and to the fountain monotypes, *Water Above and Below* and *Fountain Burning Vessel*. Because of Cumming's involvement in public sculpture projects such as his commission work for Lowell, Massachusetts, these designs might eventually be realized in stone. Their stature implies consequence, just as the repetition of images does. Their apparent size is at the other end of the scale from the more domestic-sized architectural imagery that appears in other works.

The house shape, whose relatively small size is intimated by the point of view in which it is represented, is seen in *Skies of Blue*, a monotype produced at the same time as *Elgin* and *Baltic Rule*. Developing over the same period as the flame motif, the carton or house shape seen here has the same potential as a container as the coil in *Black Ball*, except that here it seems less foreboding. A sunny scene seems to be depicted on the outside of the tiny carton riding the dark waves that surround it. Eventually a similar shape, which is now more like a schematized house, is conjoined with the image of fire in a series of watercolors including *Burning Box: Lid Open*, then produced as a woodcut *Burning Box*, where it seems a repository for some powerful radiance.

It would be foolish to try to analyze the nature of the light that spills from *Burning Box: Lid Open*, just as it is foolish to describe a rose as "a convoluted red form with a linear green attachment." Robert Cumming's work causes us to think closely about the nature of such icons and the way that within their layers of meaning exist disparate, even opposing nuances.

Andrew Stevens
Curator

Artist's Statement

When called upon to comment on what I do, I usually say, for starters, that I depict objects. I'm an artist of "things." Beyond that, I find the going rough; the kind of object chosen, how it is rendered, and in which medium varies so much from work to work. Chuck Hagen, in a conversation with me several years ago, broadly referred to my works as "meditations," and I think that's an important observation. I love ordinary things, the manufactured things of our time; chairs, cups, birdhouses, light bulbs, rulers, etc. With a simple alteration here, one of these object-archetypes can be as temporal as the cast-iron bank or the dirigible; with a simple alteration there, it can be projected into a longer-lived family of symbols. It remains to be seen whether the two-decade-old "smiley face" will stand the millennial test of time that the "plus" sign or Roman numerals have. In this natural selection of objects, some are failures from the start—wear down, burn out, and are cast off; some are modified, improved upon with change; those that survive are rarities.

Additionally, I'm intrigued by the grammar of representation. A palette, for instance, can be isolated from a small but very old family of art-making tools, but with a minor change in outline, a reorganization of surface features, it becomes a death's head. The new hybrid is still recognizable as both palette and skull, but now speaks to a fuller circle of meaning from creation to termination. I'm impressed that meaning within such a narrow and simple framework can be so malleable, that it has within the schematization such ability for transition.[1]

Finally, there permeates the choice of these new/old objects, an attraction to conflicting dualities. What is the humor found in the brutality of slapstick comedy? Who is the Eagle scout become the mass murderer? How can there be such deep intuition of natural order (and disorder) in the work of "naive" or folk artists? And why is there frequently such insanity at the heart of such well-thought-out constructs (*Mein Kampf*, warehouses of documents at the Patent Office, the schemes of religious fundamentalists to supplant the obvious premise and process of evolution, to name a few)? The Plague supposedly entered Europe through Venice in a shipload of beautifully woven fabric from the East. "We had to destroy the village to save it."

Robert Cumming
June, 1991

1. The first palettes I produced were inspired in the early 1980s by a painting by "naive" artist Morris Hirshfield. *The Artist and His Model* (1945) depicts a dilettante (perhaps French) painter: scroll moustache, pin-striped pants emerging from beneath a sashed smoking jacket, and, perched on a flimsy little pedestal, his nude model is grasping her robe. In the artist's hand is a palette with a handle (looking something like a scaled-down pizza oven paddle; square bottom, rounded top). It has a tidy blue border and an aggressive wood grain on which are geometrically set nine discrete splotches of paint: three down, three across, each a circular dot of solid color. The dot arrangement looked like the slightly more complex diagrams then being used by physicists to illustrate the characteristics of the newly discovered quark particles which had "colors" of red, white, and blue, as well as "flavors" of up, down, strange, and charmed. I've never cared for art works that comment solely on the attributes of art production, but here, in this implausible object, the far-fetched details of a folk art studio fantasy and quark theory physics crossed momentarily. The light that went on for me was of a palette of grander scope: the mixing plane for all the elements of nature with countless possibilities—dimension, form, time, etc. From off its surface come all the concoctions of creation; from the Big Bang to the rotating spirals of far-off galaxies; dinosaurs as well as ants at a picnic. I've since done many of my own palette variations: two-handled ones, some shaped like commas. *Burgess Palette* is in the shape of a tiny horseshoe crablike creature from the 530 million year-old Burgess Shale. A fossilized piece of ancient sea bottom, it was found high up in the Canadian Rockies.

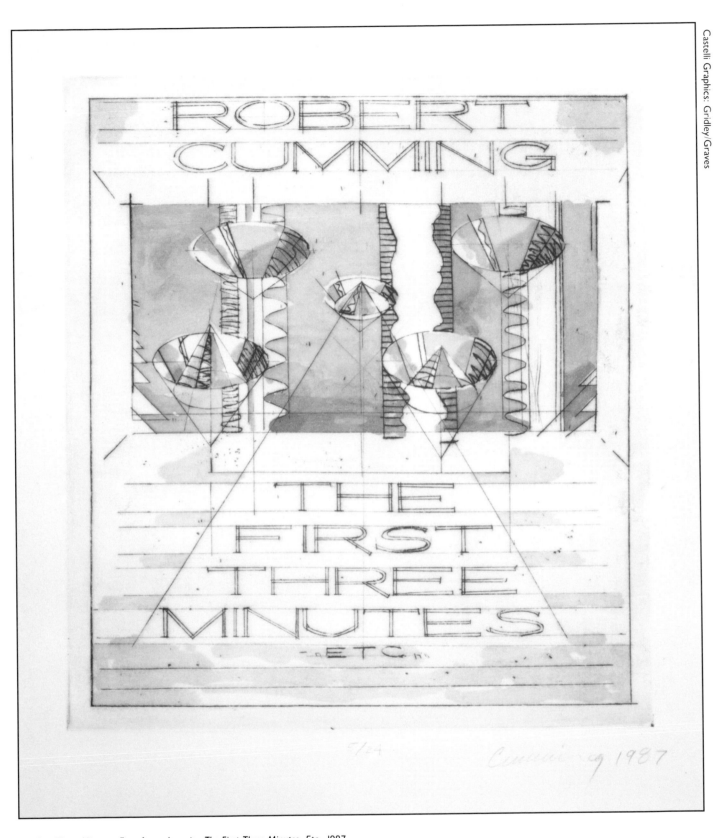

The First Three Minutes, Etc., from the suite *The First Three Minutes, Etc.,* 1987
Drypoint with watercolor on John Koller Special paper, 13¾ × 13 in.
AP 2/6*, printed at Vermillion Editions by Steve Andersen with Susan Steinbrock and Mary Pat Opatz
Published by Vermillion Editions
Courtesy of the artist

*Please note that the edition numbers in the text refer to
the works used in the exhibition, not necessarily the works
pictured.

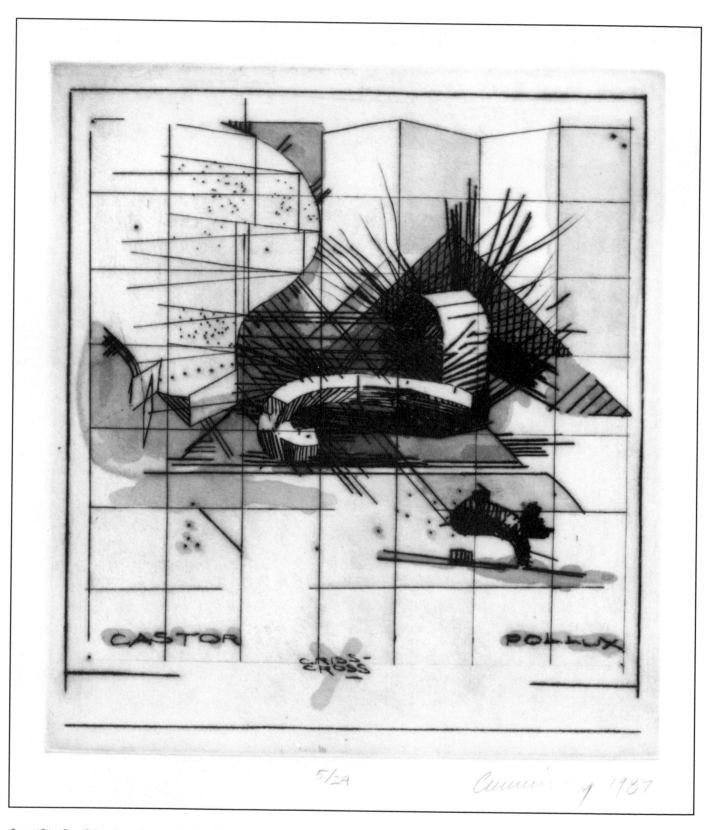

Castor/Criss Cross/Pollux, from the suite *The First Three Minutes, Etc.*, 1987
Drypoint with watercolor on John Koller Special paper, 13¾ × 13 in.
AP 2/6, printed at Vermillion Editions by Steve Andersen with Susan Steinbrock and Mary Pat Opatz
Published by Vermillion Editions
Courtesy of the artist

Castelli Graphics: Gridley/Graves

Alpha K Copy, from the suite *The First Three Minutes, Etc.*, 1987
Drypoint with watercolor on John Koller Special paper, 13 3/4 × 13 in.
AP 2/6, printed at Vermillion Editions by Steve Andersen with Susan Steinbrock and Mary Pat Opatz
Published by Vermillion Editions
Courtesy of the artist

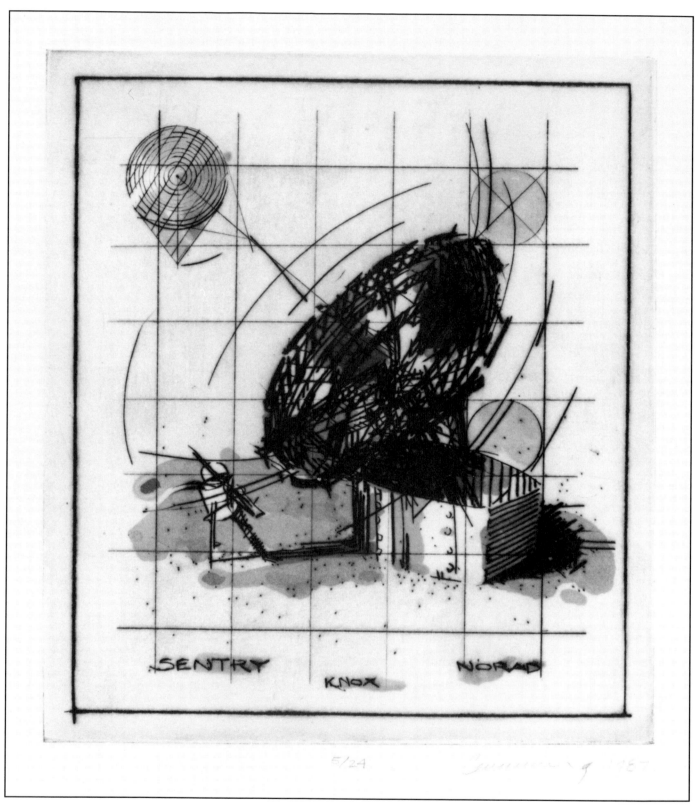

Sentry Knox Norad, from the suite *The First Three Minutes, Etc.*, 1987
Drypoint with watercolor on John Koller Special paper, 13¾ × 13 in.
AP 2/6, printed at Vermillion Editions by Steve Andersen with Susan Steinbrock and Mary Pat Opatz
Published by Vermillion Editions
Courtesy of the artist

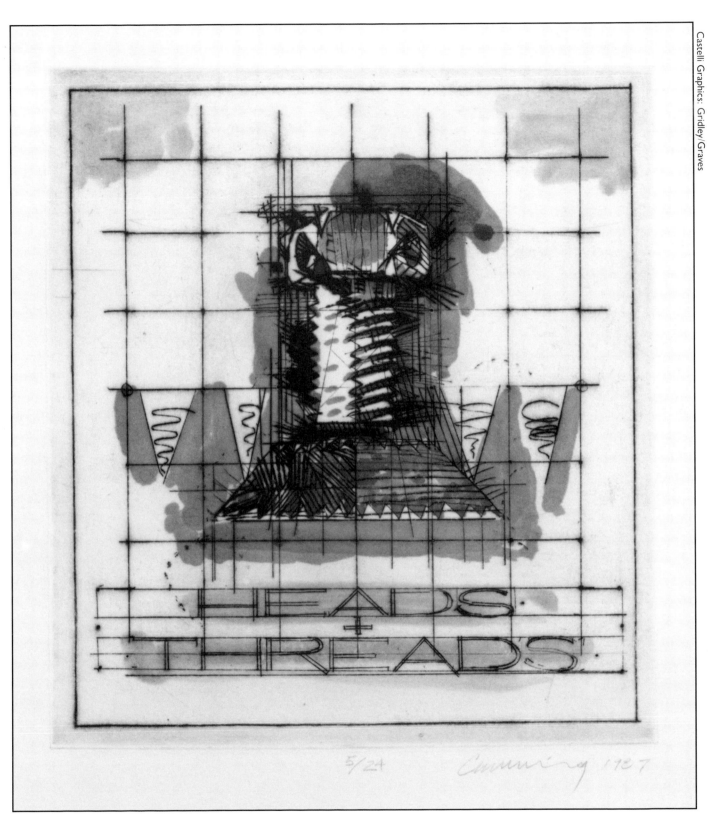

Heads + Threads, from the suite *The First Three Minutes, Etc.,* 1987
Drypoint with watercolor on John Koller Special paper, 13³/4 × 13 in.
AP 2/6, printed at Vermillion Editions by Steve Andersen with Susan Steinbrock and Mary Pat Opatz
Published by Vermillion Editions
Courtesy of the artist

Castelli Graphics: Gridley/Graves

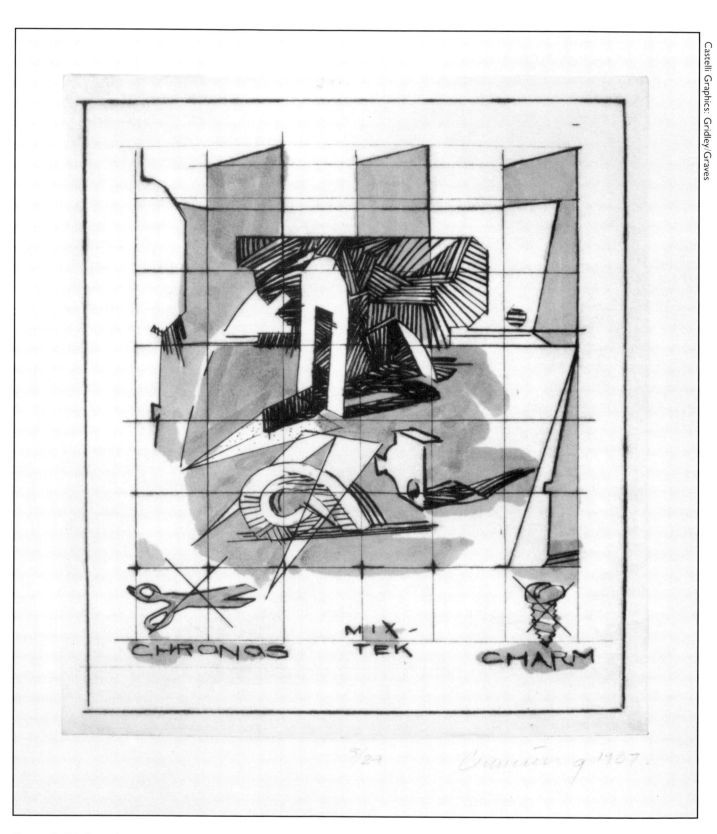

Chronos Mix-Tek Charm, from the suite *The First Three Minutes, Etc.*, 1987
Drypoint with watercolor on John Koller Special paper, 13¾ × 13 in.
AP 2/6, printed at Vermillion Editions by Steve Andersen with Susan Steinbrock and Mary Pat Opatz
Published by Vermillion Editions
Courtesy of the artist

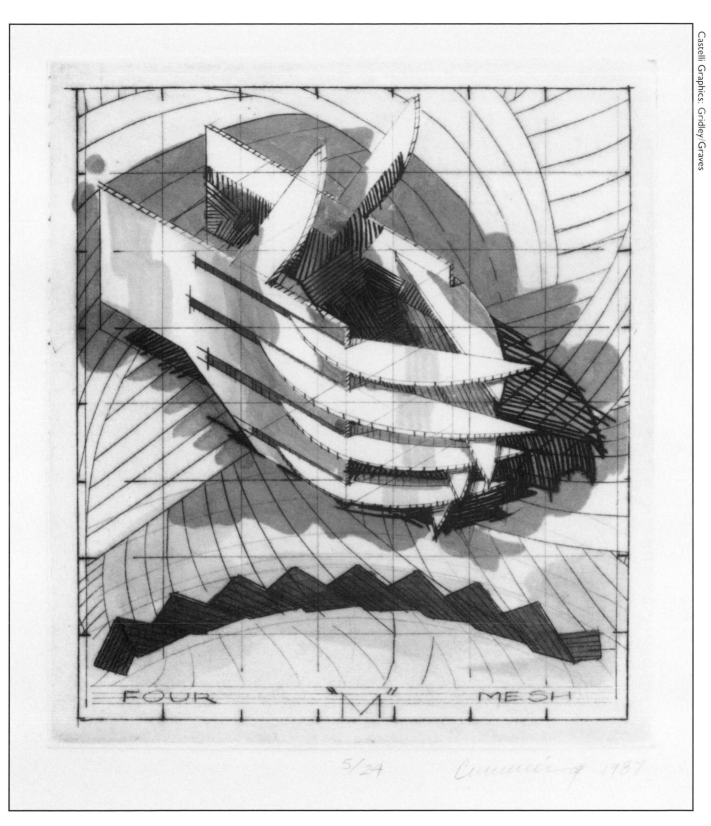

Four "M" Mesh, from the suite *The First Three Minutes, Etc.*, 1987
Drypoint with watercolor on John Koller Special paper, 13 3/4 × 13 in.
AP 2/6, printed at Vermillion Editions by Steve Andersen with Susan Steinbrock and Mary Pat Opatz
Published by Vermillion Editions
Courtesy of the artist

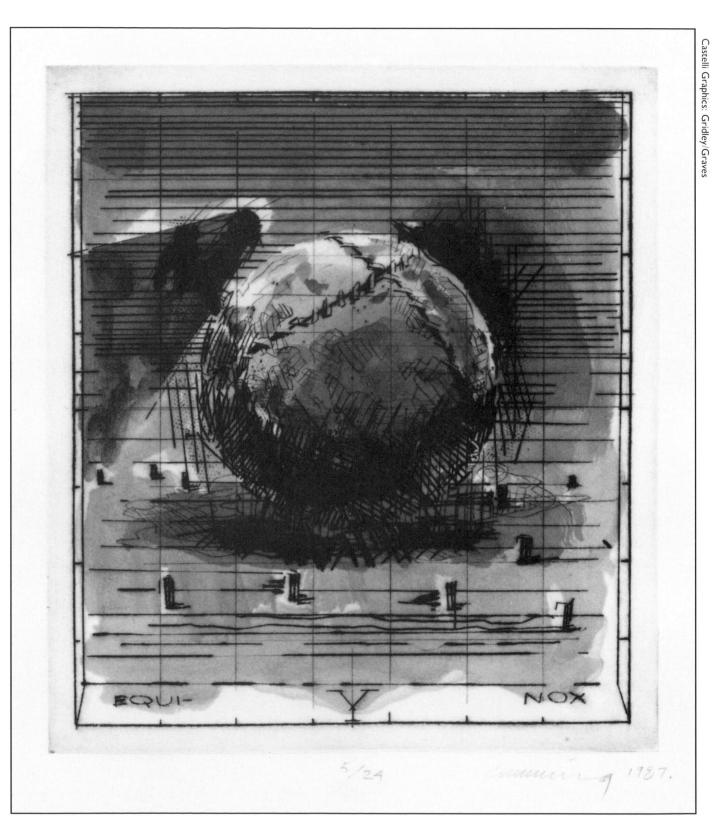

Equi-Y Nox, from the suite *The First Three Minutes, Etc.*, 1987
Drypoint with watercolor on John Koller Special paper, 13 3/4 × 13 in.
AP 2/6, printed at Vermillion Editions by Steve Andersen with Susan Steinbrock and Mary Pat Opatz
Published by Vermillion Editions
Courtesy of the artist

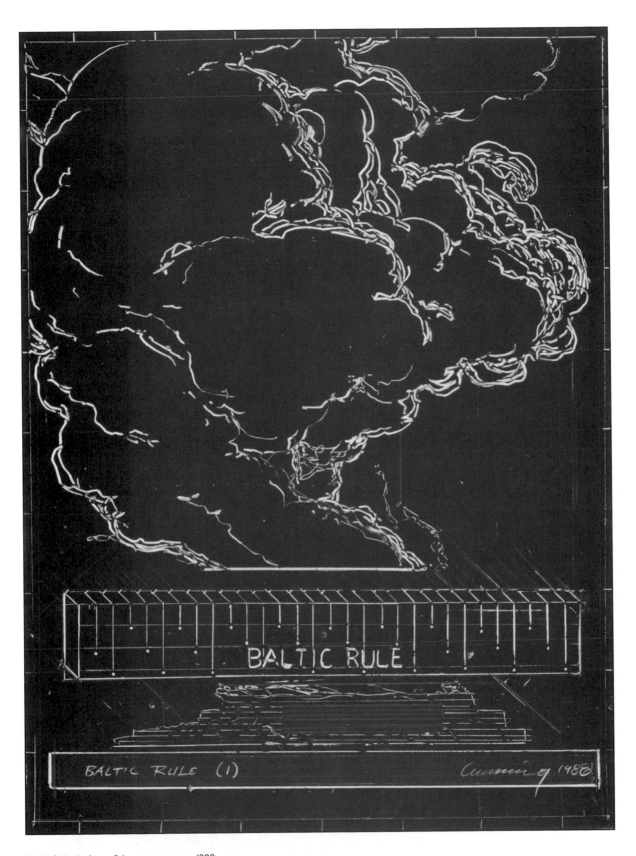

Baltic Rule (I), from *Odessa* monotypes, 1988
Monotype on Arches cover paper, 30 × 22¼ in.
Part of a series of monotypes made in preparation for *Odessa*
Printed at Vinalhaven Press by John C. Erickson
Published by Vinalhaven Press
Courtesy of Vinalhaven Press

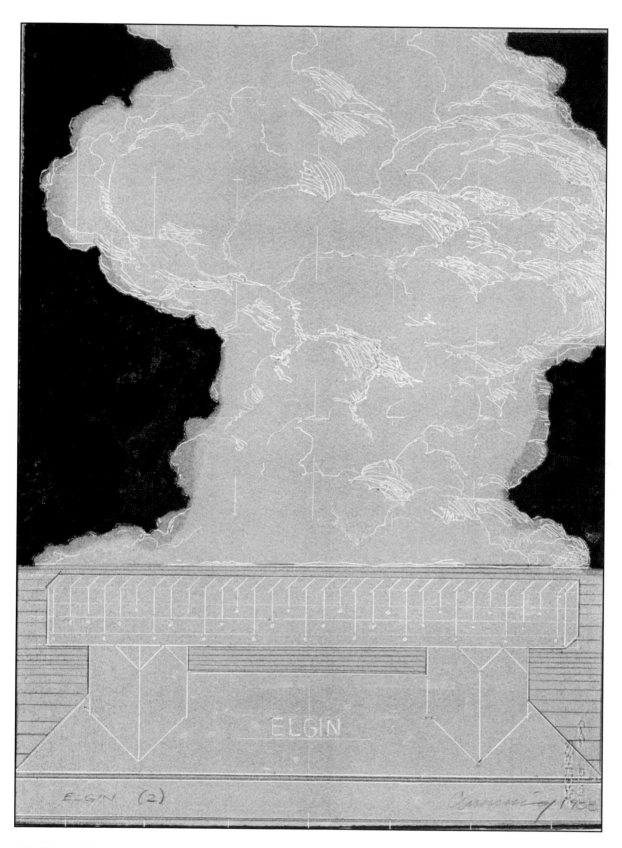

Elgin (2), from *Odessa* monotypes, 1988
Monotype on Arches cover paper, 30 × 22¹/₄ in.
Part of a series of monotypes made in preparation for *Odessa*
Printed at Vinalhaven Press by John C. Erickson
Published by Vinalhaven Press
Courtesy of Vinalhaven Press

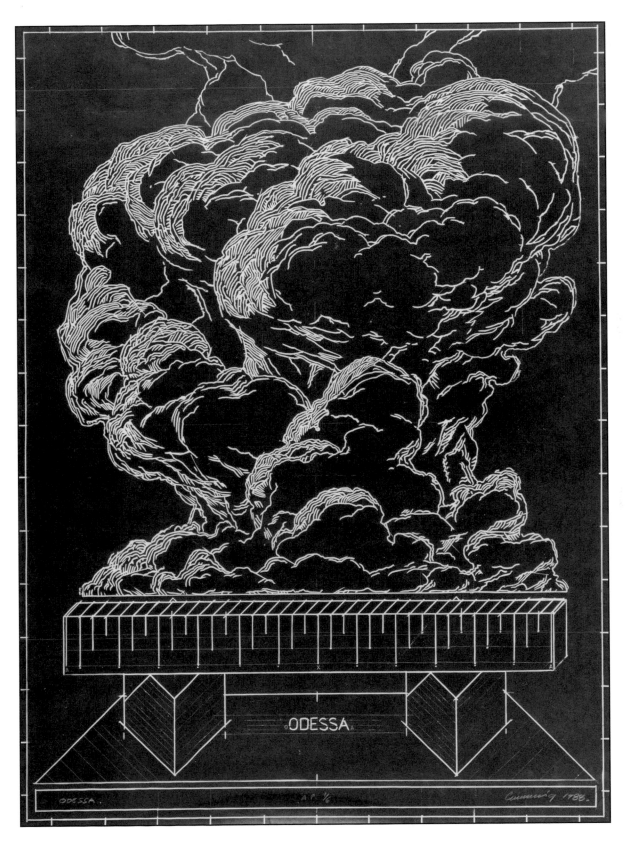

Odessa, 1988
2-color woodcut on Shoji paper, 46³/₄ × 34³/₄ in.
II/I8, printed at Vinalhaven Press by John C. Erickson and Robert McDonald
Published by Vinalhaven Press
Elvehjem Museum of Art General Endowment Fund purchase, 1989.34

19

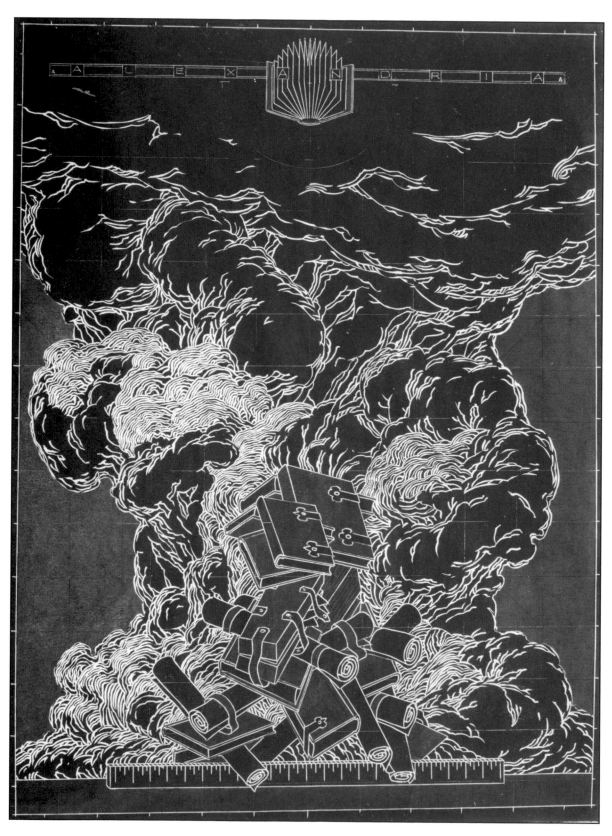

Alexandria, 1989
3-color woodcut on Shoji paper, 46³/4 × 34³/4 in.
27/30, printed at Vinalhaven Press by John C. Erickson and Robert McDonald
Published by Vinalhaven Press
Courtesy of Vinalhaven Press

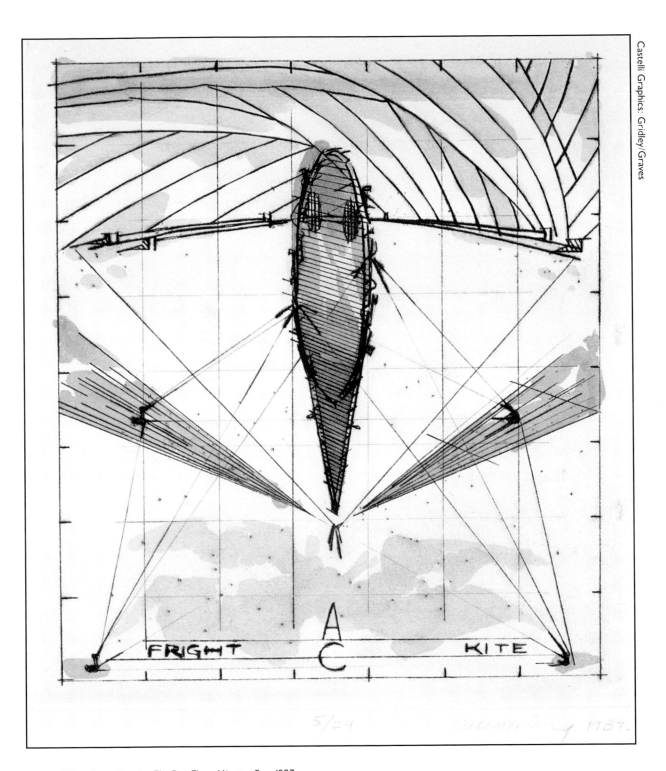

Fright A/C Kite, from the suite *The First Three Minutes, Etc.,* 1987
Drypoint with watercolor on John Koller Special paper, 13³/4 × 13 in.
AP 2/6, printed at Vermillion Editions by Steve Andersen with Susan Steinbrock and Mary Pat Opatz
Published by Vermillion Editions
Courtesy of the artist

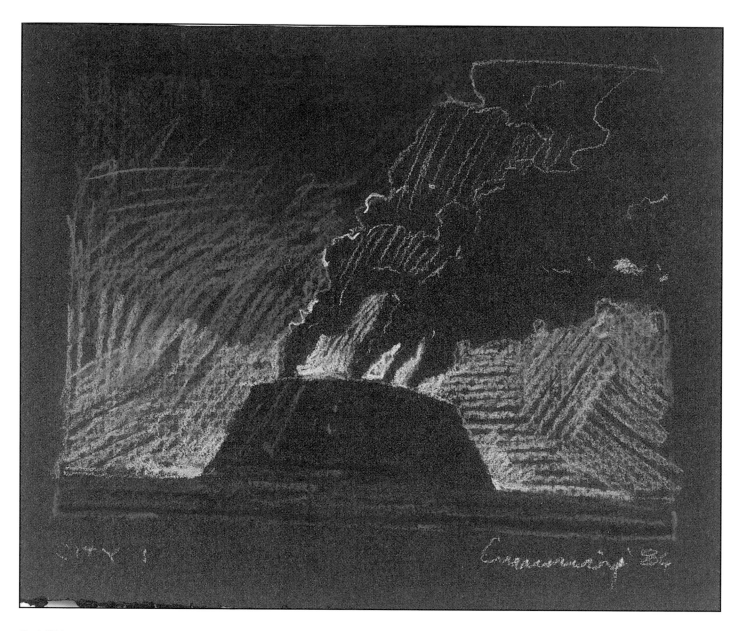

City I, 1986
Pastel on black paper, 4 1/2 × 5 1/8 in.
Courtesy of the artist

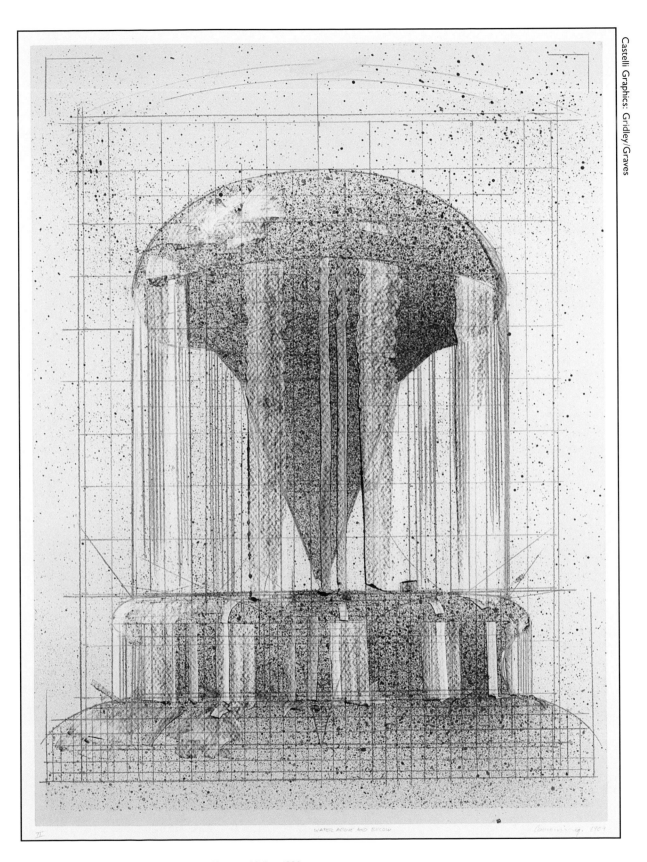

Water Above and Below, proof II, from *Water Above and Below,* 1989
Offset monotype on Rives BFK paper, 32$^{1/2}$ × 24$^{1/2}$ in.
5, printed at Derriere L'Etoile Studios by Maurice Sanchez and James Miller
Published by Derriere L'Etoile Studios
Courtesy of Derriere L'Etoile Studios

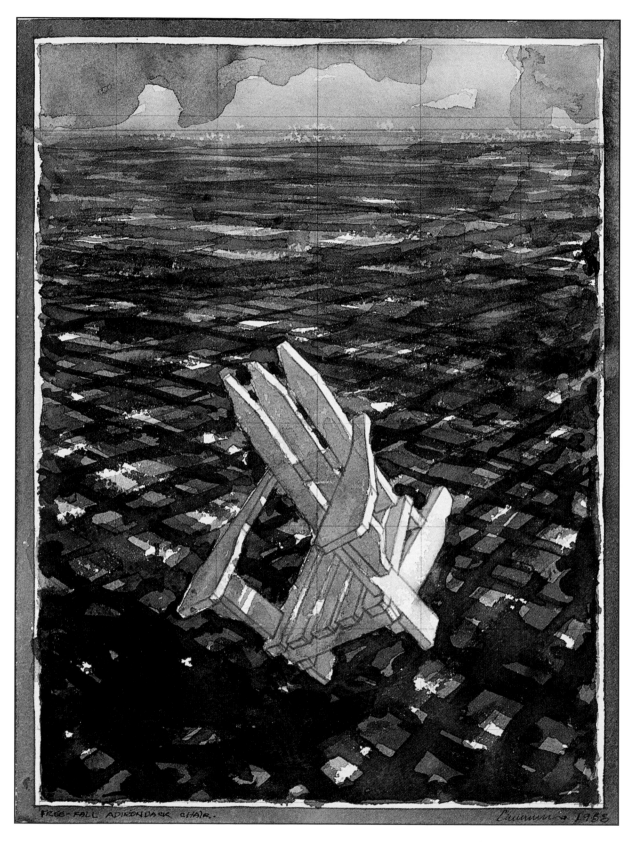

Free-fall Adirondack Chair, 1988
Watercolor, 11^{15}/$_{16}$ × 9 in.
Private collection

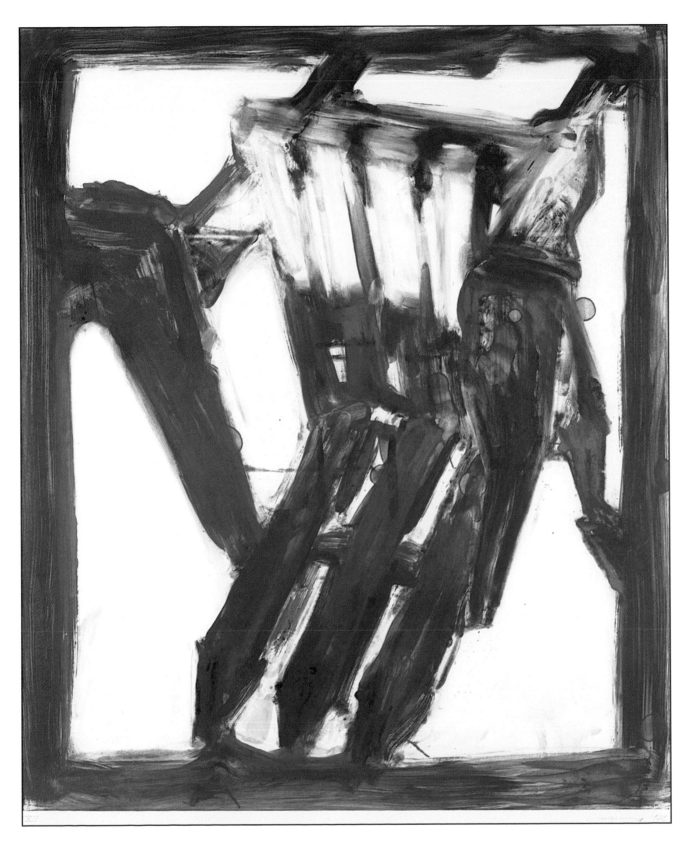

Adirondack Chair, 1988
Offset monotype on Rives BFK paper, 32⁷/₈ × 26³/₄ in.
12/12, printed at Derriere L'Etoile Studios by Maurice Sanchez
Published by Derriere L'Etoile Studios
Private collection

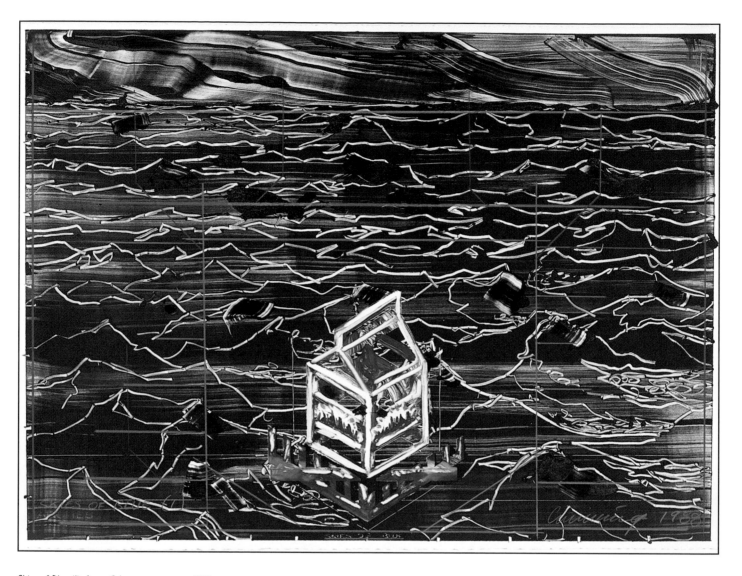

Skies of Blue (1), from *Odessa* monotypes, 1988
Monotype on Arches cover paper, 22¼ × 30 in.
Printed at Vinalhaven Press by John C. Erickson
Published by Vinalhaven Press
Courtesy of Vinalhaven Press

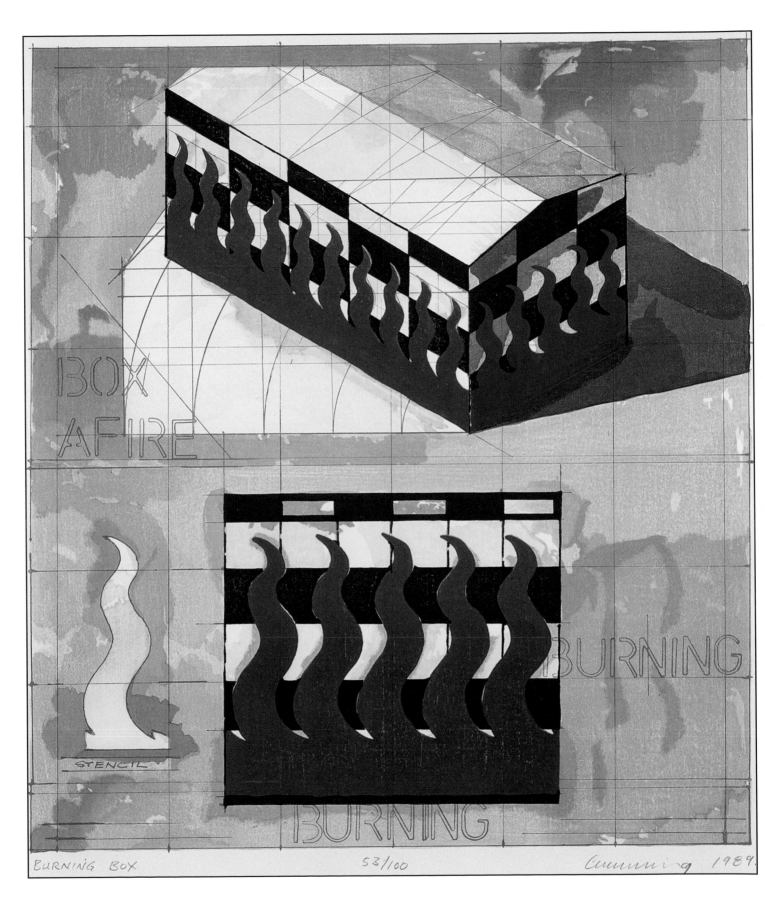

Burning Box, 1989
19-color woodcut on Torinoko paper, 22 1/2 × 20 in.
53/100, printed at Tsuka-Guchi Atelier by Shigemitsu Tsukaguchi
Published by The Print Club, Philedelphia
University of Wisconsin Art Collection Fund purchase, 1990.37

27

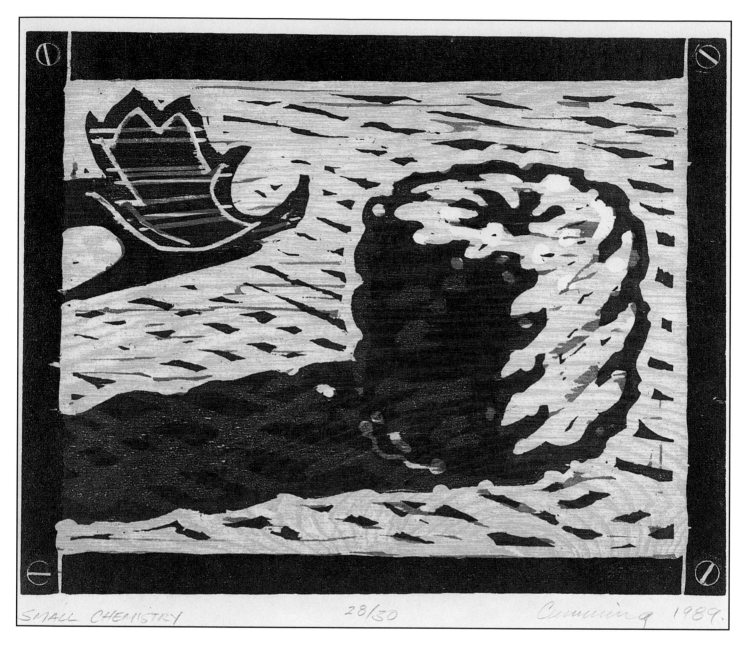

Small Chemistry, 1989
5-color woodcut on Shoji paper, 8 × 10 in.
28/30, printed at Vinalhaven Press by John C. Erickson
Published by Vinalhaven Press
Courtesy of Vinalhaven Press

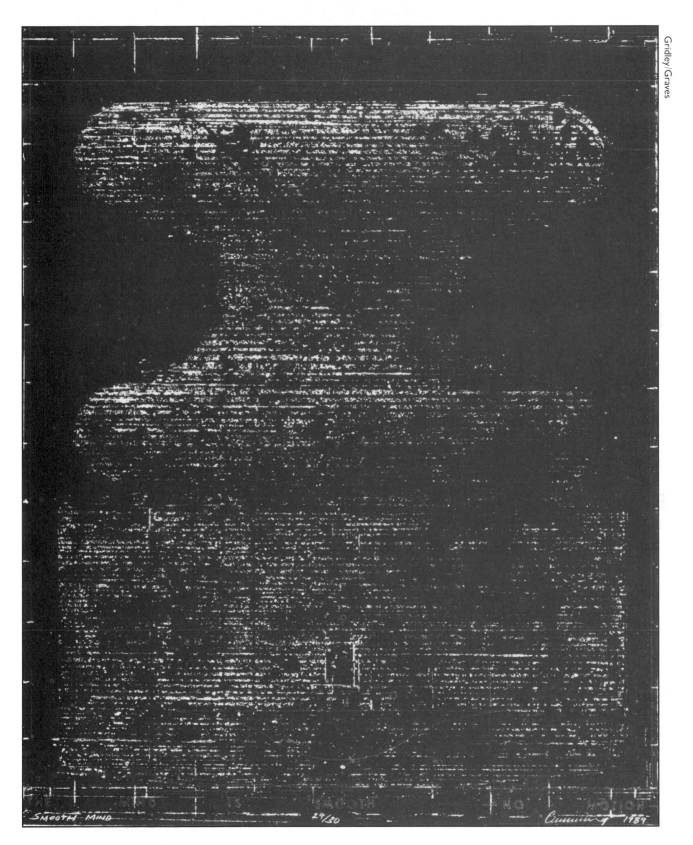

Smooth Mind, from *The Eye/Mind Set,* 1989
3-color lithograph on Rives BFK paper, 27 3/8 × 22 in.
7/30, printed at Corridor Press by Timothy Sheesley
Published by The Print Club, Philadelphia
Courtesy of Castelli Graphics

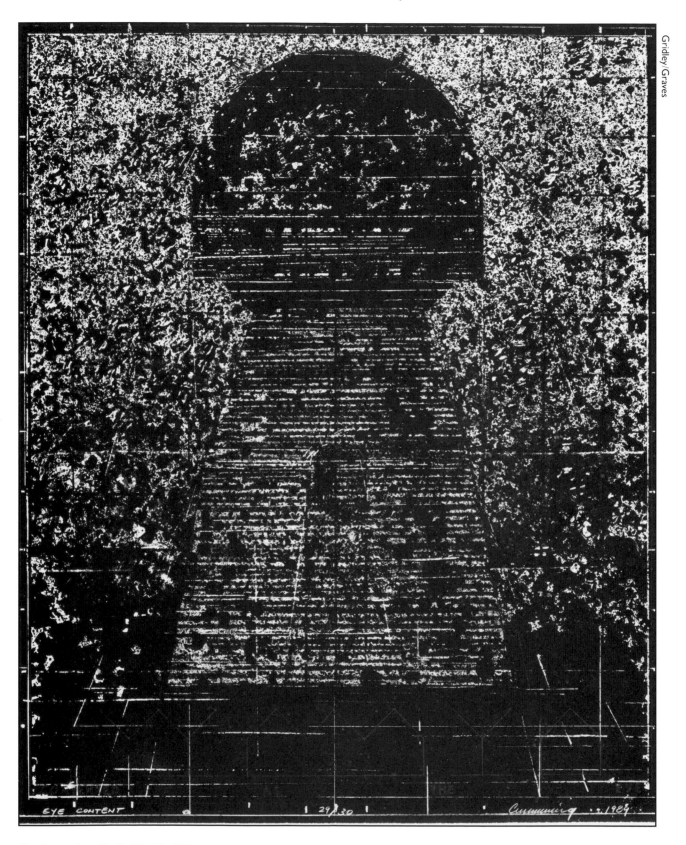

Eye Content, from *The Eye/Mind Set,* 1989
3-color lithograph on Rives BFK paper, 27 3/8 × 22 in.
7/30, printed at Corridor Press by Timothy Sheesley
Published by The Print Club, Philadelphia
Courtesy of Castelli Graphics

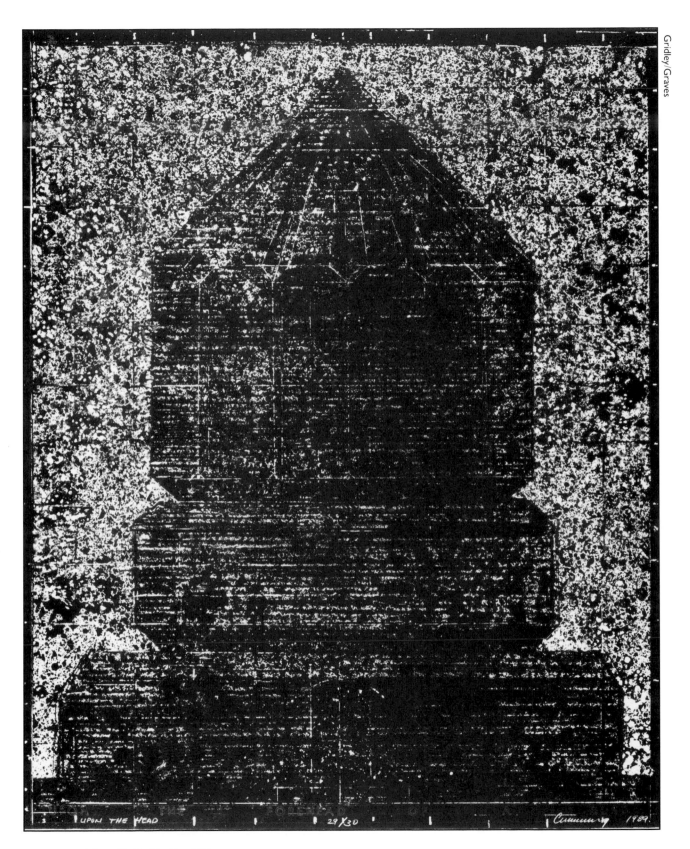

Upon the Head, from *The Eye/Mind Set,* 1989
3-color lithograph on Rives BFK paper, 27 3/8 × 22 in.
7/30, printed at Corridor Press by Timothy Sheesley
Published by The Print Club, Philadelphia
Courtesy of Castelli Graphics

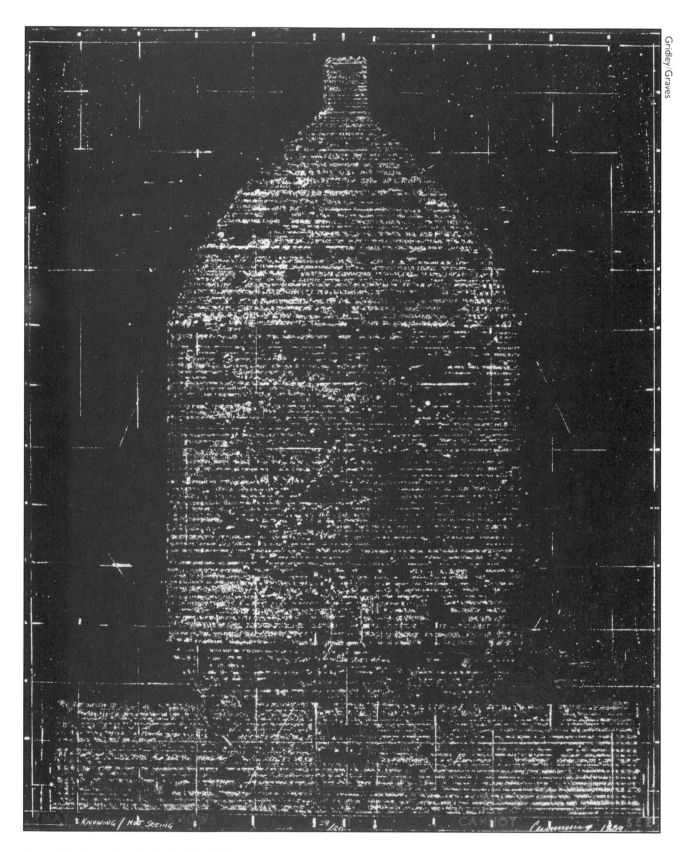

Knowing/Not Seeing, from *The Eye/Mind Set*, 1989
3-color lithograph on Rives BFK paper, 27 3/8 × 22 in.
7/30, printed at Corridor Press by Timothy Sheesley
Published by The Print Club, Philadelphia
Courtesy of Castelli Graphics

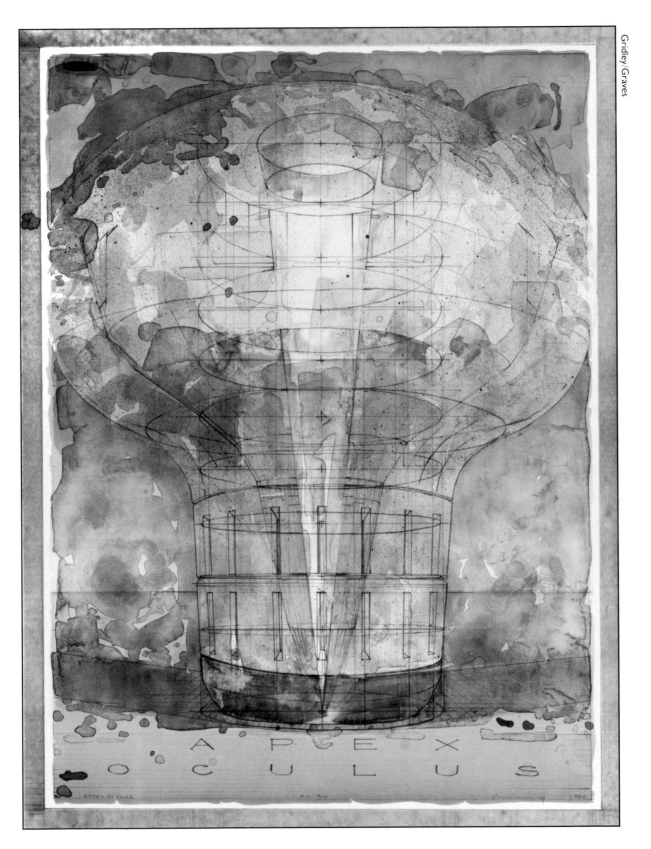

Apex Oculus, 1985
8-color lithograph on Rives BFK paper, 39 1/2 × 29 1/4 in.
Edition of 60 press proof 4/5, printed at Vermillion Editions by Steve Andersen with Philip Barber and Michael Herstand
Published by Vermillion Editions
Courtesy of Castelli Graphics

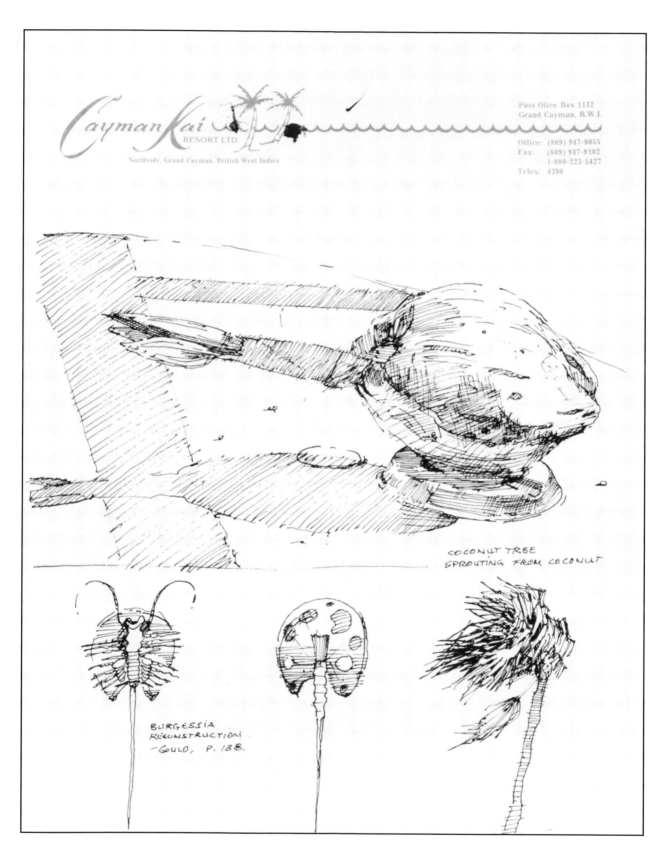

Burgesia, Palette, and Palm, 1/1990
Pen and ink on stationary, 11 × 8¹/₂ in.
Courtesy of the artist

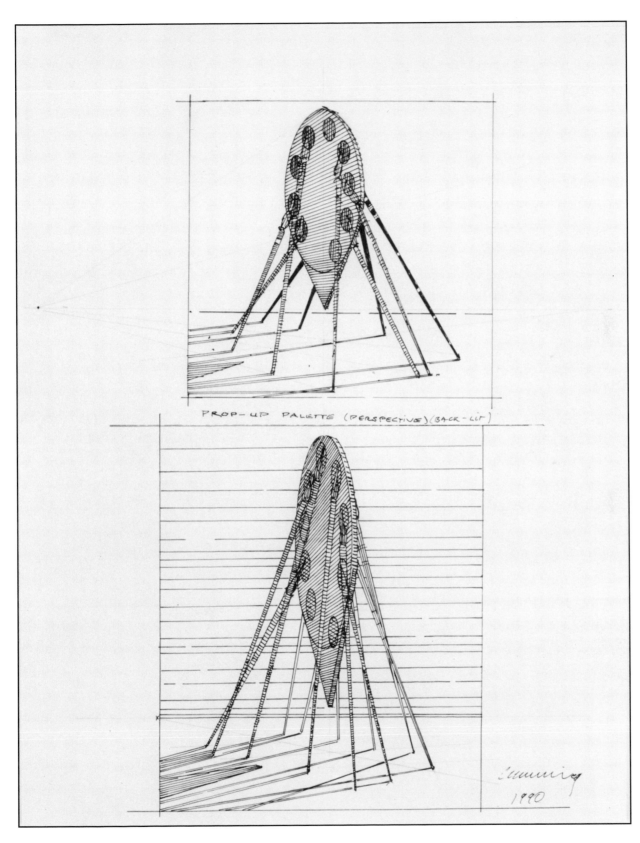

PROP-UP PALETTE (PERSPECTIVE)(BACK-LIT)

Prop-up Palette, 1990
Pen and ink on typing paper, 11 × 8 1/2 in.
Courtesy of the artist

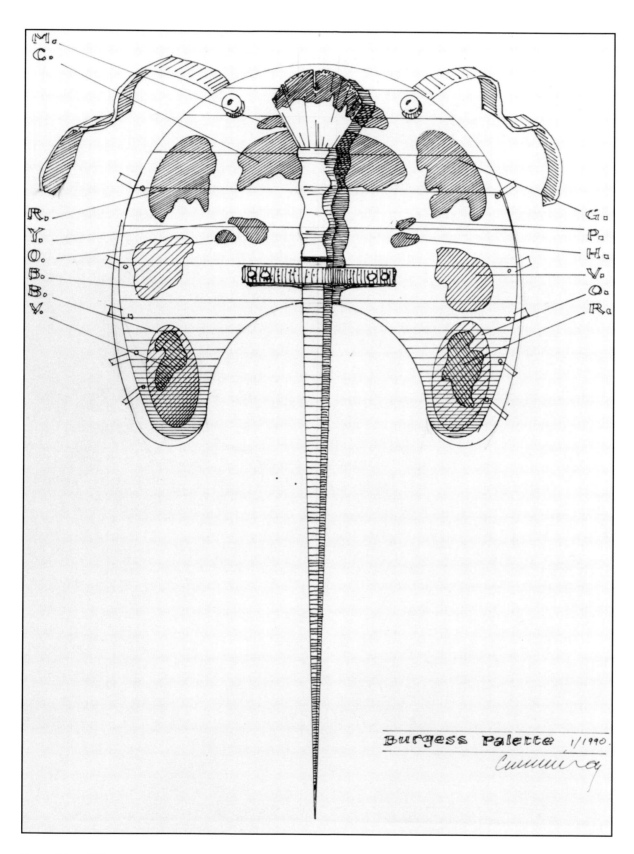

Burgess Palette, 1990
Pen and ink on typing paper, 11 × 8¹/₂ in.
Courtesy of the artist

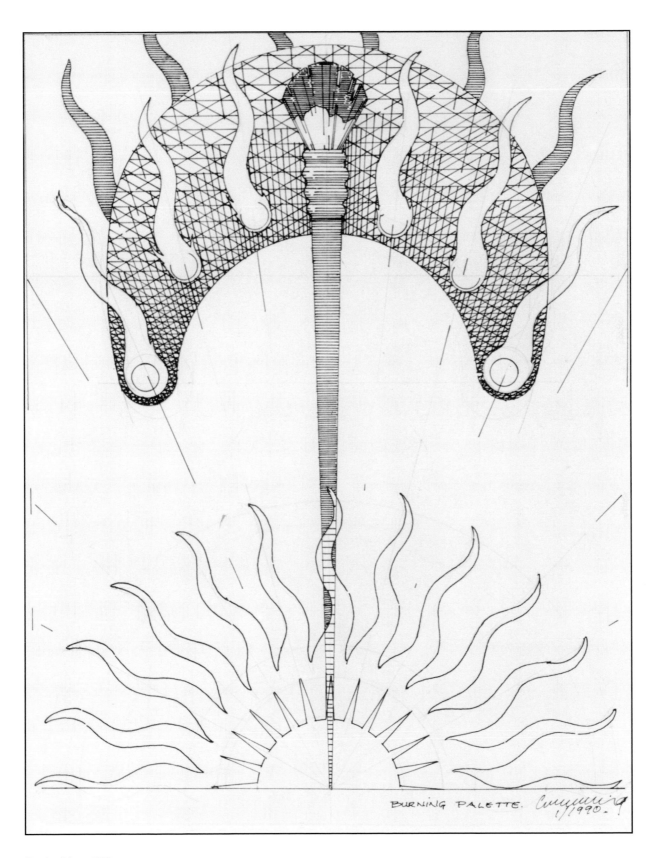

Burning Palette, 1990
Pen and ink on typing paper, 11 × 8 1/2 in.
Courtesy of the artist

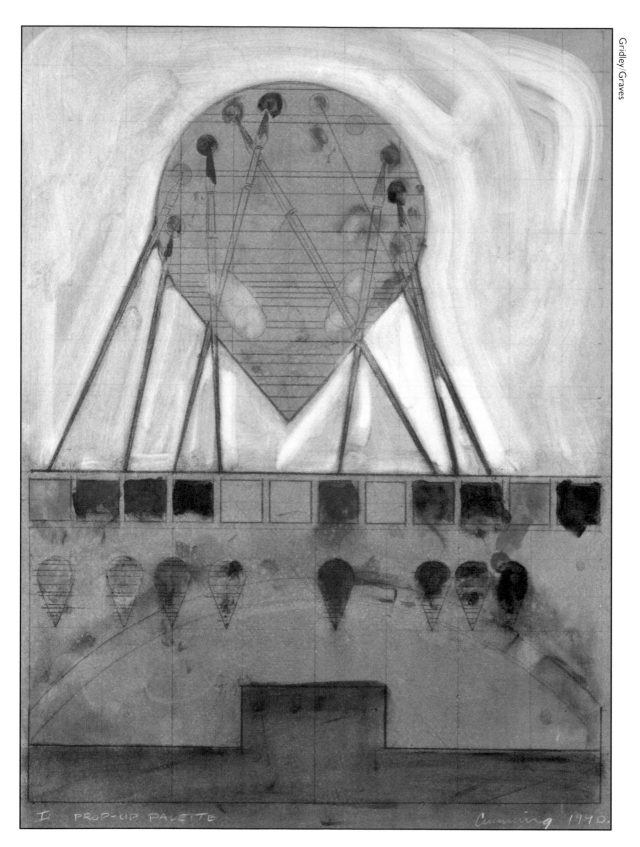

Prop-up Palette I, 1990
Offset monotype on Rives BFK paper, 29¹⁵/₁₆ × 22 in.
7, printed at Derriere L'Etoile Studios by Maurice Sanchez and James Miller
Published by Derriere L'Etoile Studios
Courtesy of Castelli Graphics

38

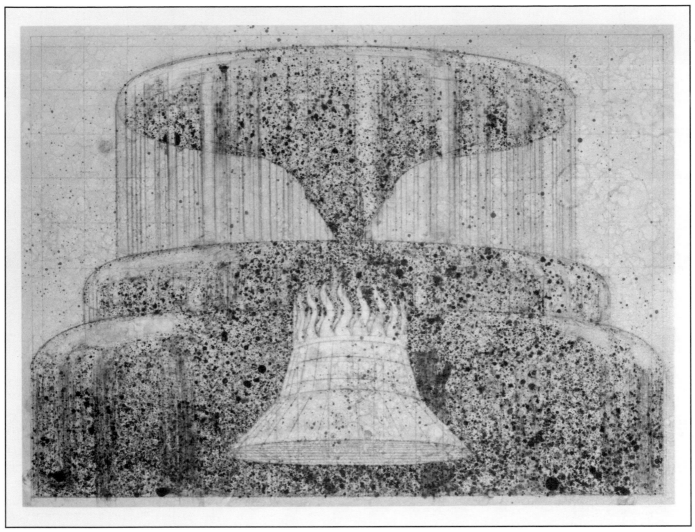

Fountain, Burning Vessel, 1990
Offset monotype on Rives BFK paper, 22 × 30 in.
2/8, printed at Derriere L'Etoile Studios by Maurice Sanchez and James Miller
Published by Derriere L'Etoile Studios
Courtesy of Castelli Graphics and Derriere L'Etoile Studios

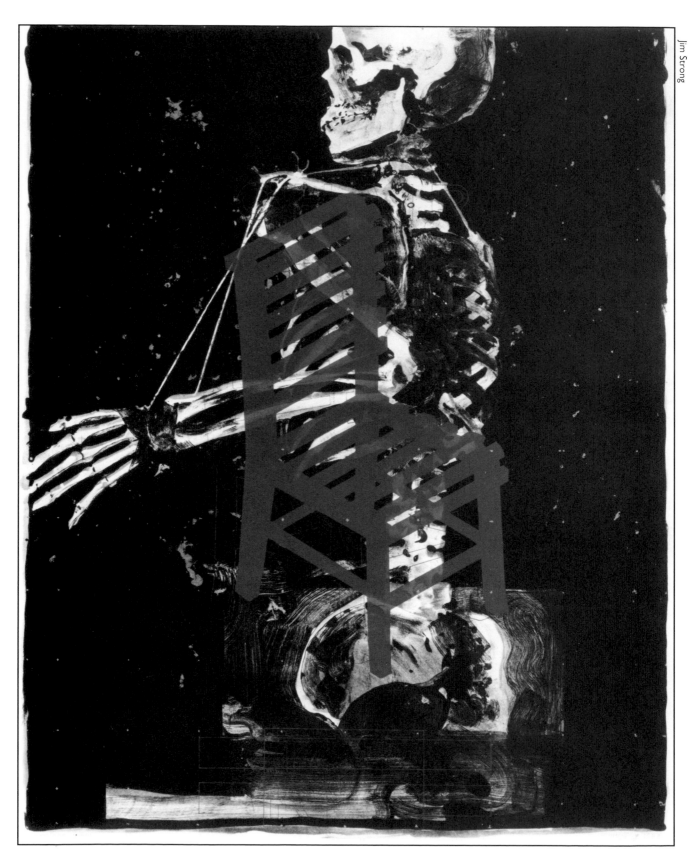

Red Chair, 1986
3-color lithograph and silkscreen on Rives BFK paper, 48¹/₂ × 38 in.
3/25, printed at Derriere L'Etoile Studios by Maurice Sanchez and James Miller
Published by Castelli Graphics and Derriere L'Etoile Studios
Courtesy of Castelli Graphics

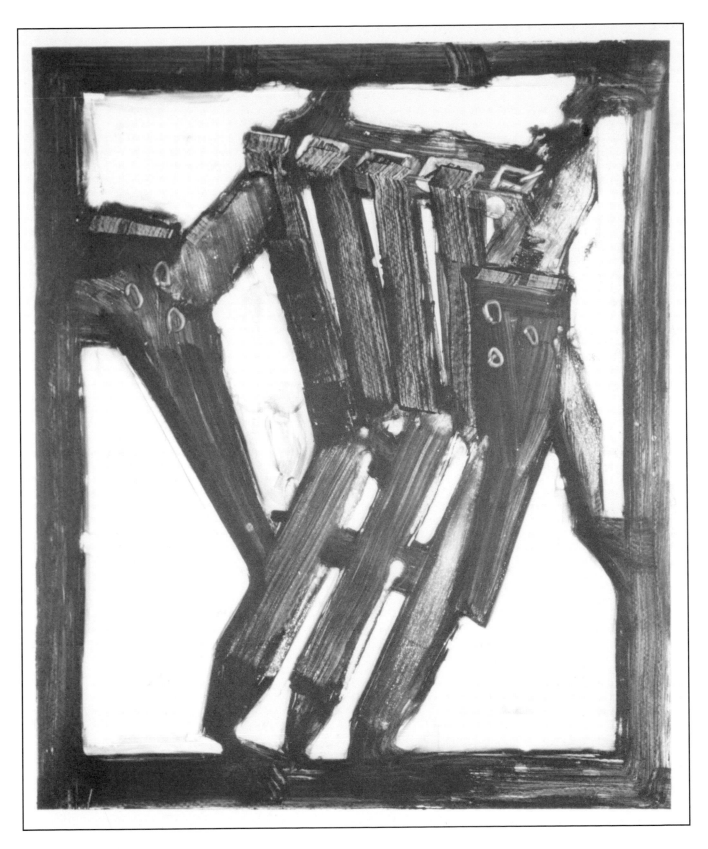

Adirondack Chair, 1988
Offset monotype on Rives BFK paper, 32⁷/₈ × 26³/₄ in.
4/12, printed at Derriere L'Etoile Studios by Maurice Sanchez
Published by Derriere L'Etoile Studios
Elvehjem Museum of Art General Endowment Fund purchase, 1988.69

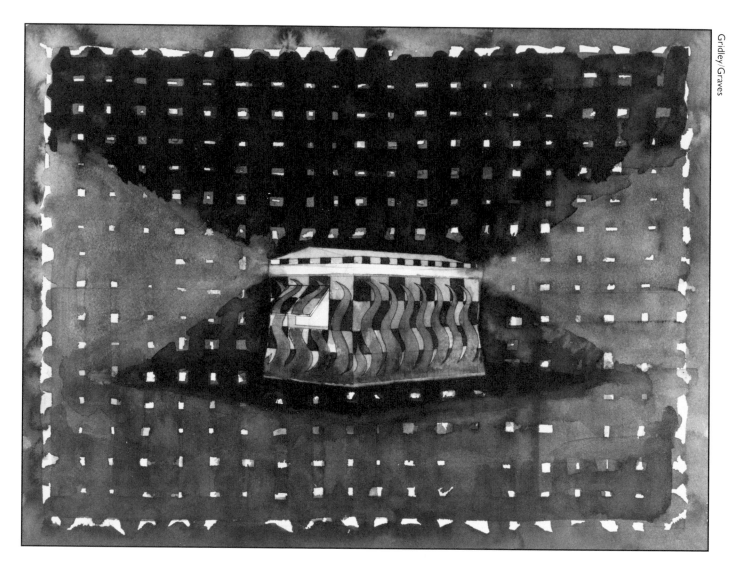

Burning Box: Lid Open, 1988
Watercolor, 12¼ × 16 in.
Courtesy of Castelli Graphics

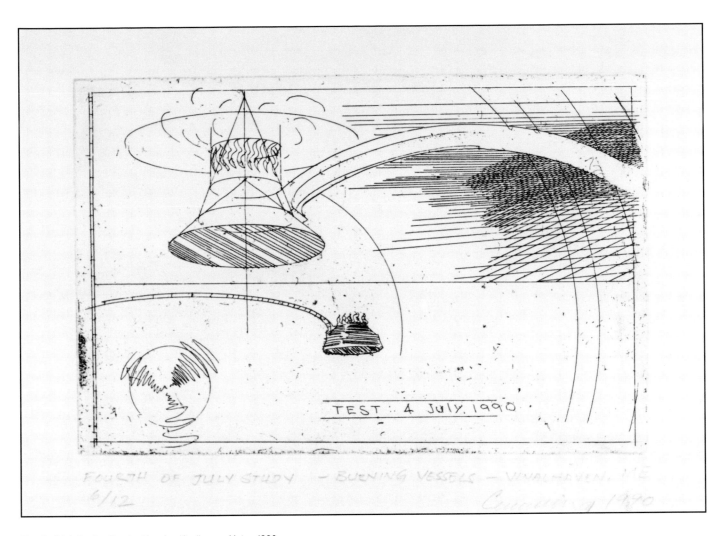

TEST : 4 July. 1990

Fourth of July Study—Burning Vessels—Vinalhaven, Maine, 1990
Etching on Arches cover paper, 4 × 6 in.
6/12, printed at Vinalhaven Press by Brenda Zlamany
Published by Vinalhaven Press
Courtesy of Vinalhaven Press

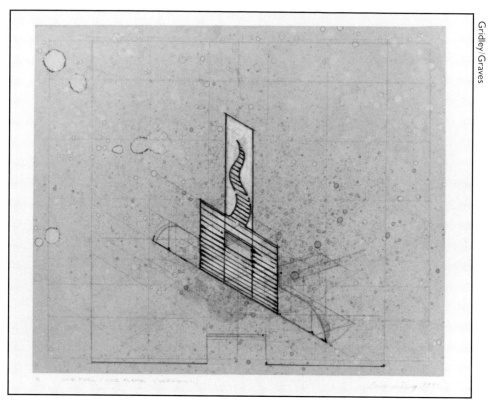

One Fuel/One Flame (version 1), 1991
Monotype on Arches paper, 11¾ × 13 in. each
Edition of 8, printed by Maurice Sanchez
Published by Derriere L'Etoile Studios and Smith College
Courtesy of Castelli Graphics and Derriere L'Etoile Studios

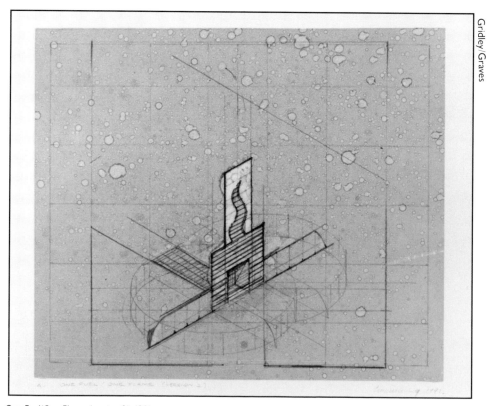

One Fuel/One Flame (version 2), 1991
Monotype on Arches paper, 11¾ × 13 in. each
Edition of 8, printed by Maurice Sanchez
Published by Derriere L'Etoile Studios and Smith College
Courtesy of Castelli Graphics and Derriere L'Etoile Studios

Four "M" Mesh sketch, 1986
Pen and ink, 2³/₄ × 3 in.
Courtesy of the artist

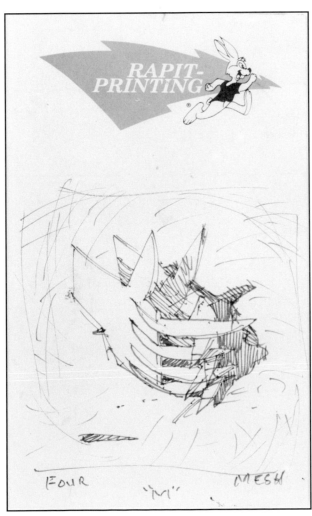

Four "M" Mesh sketch, 1986
Ballpoint pen on notepad paper, 7 × 4¹/₄ in.
Courtesy of the artist

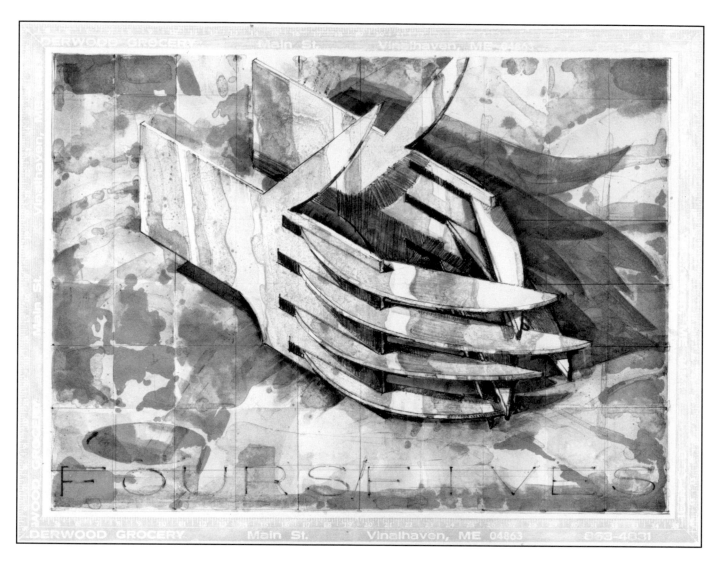

Fours/Fives, 1987
6-color lithograph on Arches cover paper, 27 1/2 × 40 1/4 in.
34/34, printed at Vinalhaven Press by John C. Erickson with Frank Akers and Barbara Balfour
Published by Vinalhaven Press
Courtesy of Vinalhaven Press

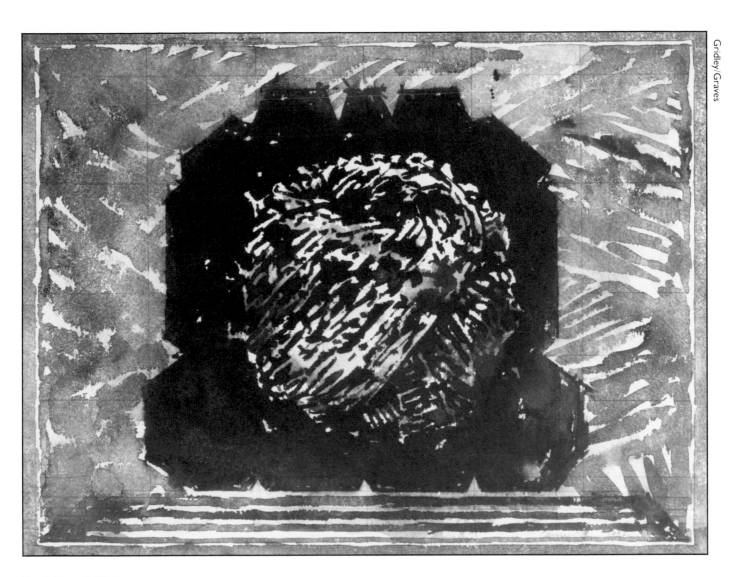

Untitled (twine), 1986
Watercolor, 10 × 12⁷/8 in.
Courtesy of Castelli Graphics

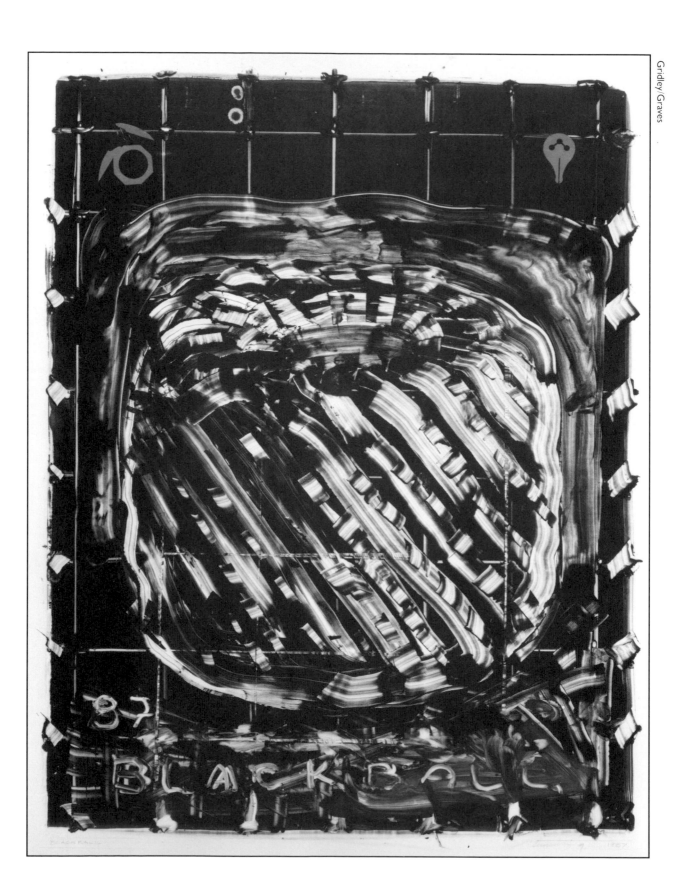

Black Ball I, from *National Geographic Series*, 1987
Monotype on Arches cover paper, approx. 30 × 30 in.
2, printed at Vinalhaven Press by John C. Erickson
Published by Vinalhaven press
Courtesy of Castelli Graphics